The Love Story:
Break Your Heart Open

CREDITS:

Executive Producer:
Mingjie Zhai

Associate Producers:
Wade Chao
Monica Dziak
Sandy Leung
Leila Pari
Sherman Wellons

Video Editor: Mingjie Zhai
Sound Editor: Seth Brogdon
Editor-in-Chief: Mingjie Zhai
Assistant Copy Editors: Alex Jacobs, Stephanie Mercado, & Amber Zhai

Cover Illustration and Mandala: Jesse Alter
The Love Story (Front Half) Portrait Illustrator: Sirine Cherif
The Art of Letting Go (Back Half) Portrait Illustrator: Xiao Ming Tang
Graphic Designer: Justin Oefelein

In Partnership with: Live Portrait

The Love Story: The Art Of Letting Go

Antonique Smith
behind *Love is Everything*
https://thelovestory.org/project/behind-love-is-everything/
Producer: Mingjie Zhai
Interviewer: Amber Zhai
Camera: Dereck Cleveland & Sherman Wellons
Special Thanks to: Darryl Smith and Lobby Studios

Kera Armendariz
behind "Snakes"
https://thelovestory.org/project/behind-snakes/
Producer: Monica Dziak
Interviewer: Monica Dziak
Camera: Norio Chalico & Mingjie Zhai

Tomer Peretz
behind *Unbreakable*
https://thelovestory.org/project/behind-unbreakable/
Producer: Monica Dziak
Interviewer: Monica Dziak
Camera: Norio Chalico & Mingjie Zhai

Lucas David
behind *People Are Strange*
https://thelovestory.org/project/behind-unbreakable/
Producer: Monica Dziak
Interviewer: Monica Dziak
Camera: Norio Chalico & Mingjie Zhai

Kiyoshi Shelton
behind *I Am the Light*
https://thelovestory.org/project/I-Am-the-Light
Producer: Mingjie Zhai
Interviewer: Alysta Lim
Camera: Jeredon O' Conner, Arin Degroff, Jesse Rivas, Mingjie Zhai
Production Assistants: Athena Lim & Andrea Green

Krista Richards
behind *Broken*
https://thelovestory.org/project/behind-broken
Producer: Mingjie Zhai
Interviewer: Mingjie Zhai
Camera: Jeredon O' Conner, Jesse Rivas, Mingjie Zhai
Production Assistants: Athena Lim & Alysta Lim

Indy Rishi
behind the Laughter
https://thelovestory.org/project/behind-the-laughter/
Producer: Mingjie Zhai
Interviewer: Alba Haya
Camera: Alba Haya & Mingjie Zhai
Special Thanks to: Edgar Cavalcanti & Jim Francesco

Indigo River
behind "Let it Go"
https://thelovestory.org/project/behind-let-go/
Producer: Mingjie Zhai
Interviewer: Mingjie Zhai
Camera: Monica Dziak & Sherman Wellons

Michelle Fitzgerald
behind Let's Eat SF
https://thelovestory.org/project/behind-lets-eat/
Producer: Sandy Leung
Interviewer: Mingjie Zhai
Camera: Mingjie Zhai

Andrea Sáenz
behind Dolce Ardor
https://thelovestory.org/project/behind-dolce-ardor/
Producer: Mingjie Zhai
Interviewer: Mingjie Zhai
Camera: Monica Dziak
Special Thanks to: DTO

Justin Taylor Phillips
behind Crywolf
https://thelovestory.org/project/behind-crywolf/
Producer: Mingjie Zhai
Interviewer: Mingjie Zhai
Camera: Wade Chao & Sherman Wellons
Special Thanks to: Adam Seid

Mick Lorusso
behind Museum of Endoluminosity
https://thelovestory.org/project/behind-museum-of-endoluminosity/
Producer: Mingjie Zhai
Interviewer: Mingjie Zhai
Camera: Wade Chao & Mingjie Zhai
Special Thanks to: UCLA Art | Sci Center

Bryan Reeves
behind The Relationship Insight Ninja
https://thelovestory.org/project/behind-insight-ninja/
Producer: Mingjie Zhai
Interviewer: Ozzy Smith
Camera: Wade Chao & Mingjie Zhai
Production Assistants: Jeffrey Annon & Jacqueline Keller

Tim Ringgold
behind Music Therapy
https://thelovestory.org/project/behind-music-therapy/
Producer: Leila Pari
Interviewer: Leila Pari
Camera: Gus Carrillo & Mingjie Zhai

Kweisi Gharreau
behind *Innocent Rage*
https://thelovestory.org/project/behind-innocent-rage/
Producer: Mingjie Zhai
Interviewer: Mingjie Zhai
Camera: Wade Chao
Production Assistants: Alysta Lim, Athena Lim, & Yiseul Kang

Donny O' Malley
behind Irreverent Warriors
https://thelovestory.org/project/behind-irreverent-warriors/
Producer: Mingjie Zhai
Interviewer: Carlos Sanchez
Camera: Jim Francesco & Carlos Sanchez
Production Assistant: Nancy Yeang
Music: Courtesy of Moby at MobyGratis.com
Special thanks to: David Pingree & Eden Trevino

Julia Price
behind "Painkiller"
https://thelovestory.org/project/painkiller/
Producer: Mingjie Zhai
Interviewer: Mingjie Zhai
Camera: Sherman Wellons & Mingjie Zhai
Special Thanks to: Samuel J

Matt Milano
behind MilanoArt
https://thelovestory.org/project/milanoart/
Producer: Mingjie Zhai
Interviewer: Mingjie Zhai
Camera: Sandy Leung
Music: BenSound.com

Mike Owens and Brent Olds
Behind Vetality Corp
https://thelovestory.org/project/behind-vetality-corp/
Producer: Mingjie Zhai
Interviewer: Inge Christie
Camera: Edgar Liquidano
Special Thanks to: Wade Chao

Hennessy Echemendia
behind "The Letter"
https://thelovestory.org/project/behind-the-letter
Producer: Mingjie Zhai
Interviewer: Wade Chao
Camera: Wade Chao and Ian Corvin

Josephina Bashout
behind Soulscape Journey
https://thelovestory.org/project/behind-soulscape-journey/
Producer: Mingjie Zhai
Interviewer: Edgar Liquidano
Camera: Edgar Liquidano & Mingjie Zhai

Mel Novak
behind Heavenly Manna
https://thelovestory.org/project/behind-heavenly-manna/
Producer: Mingjie Zhai
Interviewer: Wade Chao & Mingjie Zhai
Camera: Wade Chao & Ian Corvin

DJ Qwess Coast
behind Agape
https://thelovestory.org/project/behind-agape/
Producer: Mingjie Zhai
Interviewer: Mingjie Zhai
Camera: Wade Chao
Special Thanks to: Cross Campus

Larisa Gosla
behind "A Place Called Home"
https://thelovestory.org/project/behind-a-place-called-home/
Producer: Mingjie Zhai
Interviewer: Mingjie Zhai
Camera: Mingjie Zhai

Cheri Rae Russell
behind Peace Yoga Gallery
https://thelovestory.org/project/behind-peace-yoga-gallery/
Producer: Mingjie Zhai
Interviewer: Mingjie Zhai
Camera: Wade Chao & Sherman Wellons

Danny Brook and Lauren Rhodes
behind "My Best Friend's Suicide "and "Society"
https://thelovestory.org/project/behindsociety/
https://thelovestory.org/project/best-friends-suicide/
Producer: Mingjie Zhai
Interviewer: Mingjie Zhai
Camera: Wade Chao, Sherman Wellons & Mingjie Zhai
Special Thanks to: Shambhala Music Studio & Ras Kass

Jessica Wen
behind Light Therapy
https://thelovestory.org/project/behind-light-therapy/
Producer: Mingjie Zhai
Interviewer: Mingjie Zhai
Camera: Wade Chao
Special Thanks to: Cross Campus

Jelveh Pedraza
Behind The Redemption
https://thelovestory.org/project/behind-the-redemption/
Producer: Leila Pari
Interviewer: Leila Pari
Camera: Wade Chao & Mingjie Zhai

Dream Rockwell
behind Lucent Dossier Experience, Do Lab and Cuddle the World
https://thelovestory.org/project/behind-lucent-dossier-experience/
Producer: Mingjie Zhai
Interviewer: Mingjie Zhai
Camera: Jesse Rivas and Jeredon O' Conner
Production Assistants: Sue Chin, Stephanie Mercado, and Andrea Green
Photographer: Brant Brogan
Special Thanks to: Melissa Wynn-Jones, Russell Ward, and The Confluence Group

Samuel J
behind "All My Heart"
https://thelovestory.org/project/behind-samuel-j/
Producer: Mingjie Zhai
Interviewer: Mingjie Zhai
Camera: AJ Berger
Special Thanks to: Carla Schwiderski

Keith Murray
behind "The Suicide Song"
https://thelovestory.org/project/behind-the-suicide-song/
Producer: Mingjie Zhai
Interviewer: Mingjie Zhai
Camera: Sherman Wellons
Special Thanks to: Josh One Boomnote & Danny Brook

Peter Harper
behind "Winter Wonderland"
https://thelovestory.org/project/behind-winter-wonderland/
Producer: Mingjie Zhai
Interviewer: Nancy Yeang
Camera: Wade Chao and Jason Do
Special Thanks to: Full Circle Venice & The Folk Music Center

Moby
behind Love and Loss
https://thelovestory.org/project/healing-the-moby-story/
Producer: Mingjie Zhai
Interviewer: Mingjie Zhai
Camera: Stephanie Mercado
Special Thanks to: Jonathan Nesvadba, Russell Ward, The Confluence Group and Shambhala Music Festival

Marisabel Bazan
Behind *The Butterfly Collection*
https://thelovestory.org/project/behind-the-butterflies/
Producer: Sherman Wellons
Interviewer: Mingjie Zhai
Camera: Sherman Wellons & Mingjie Zhai
Special Thanks to: Sherman Wellons and Jesse Rivas

Cecile Guillemain
Behind "Dis-moi que tu M'aimes"
https://thelovestory.org/project/behind-de-moines-que-tu/
Producer: Wade Chao
Interviewer: Wade Chao
Camera: Wade Chao

Brent Allen Spears
behind Shrine
https://thelovestory.org/project/behind-shrine/
Producer: Mingjie Zhai
Interviewer: Chas Steiglar
Camera: Jim Francesco and Fareeth John
Production Assistant: Nancy Yoang
Special Thanks to: Kristen Woo

Dr. Sarah Neustadter
behind *Death and Love*
https://thelovestory.org/project/behind-death-and-love/
Producer: Mingjie Zhai
Interviewer: Mingjie Zhai
Camera: Wade Chao & Sherman Wellons

Ras Kass
behind *Soul On Ice*
https://thelovestory.org/project/behind-soul-on-ice/
Producer: Mingjie Zhai
Interviewer: Mingjie Zhai
Camera: Sherman Wellons
Special Thanks to: Danny Brook

Martin Dunkerton
behind LovEarth
https://thelovestory.org/project/behind-lovearth/
Producer: Mingjie Zhai
Interviewer: Ivy Joeva
Camera: Wade Chao & Mingjie Zhai
Special Thanks to: Stephen Huntsman

Rohan Dixit
behind Zenso
https://thelovestory.org/project/behind-zenso/
Producer: Mingjie Zhai
Interviewer: Mingjie Zhai
Camera: Sandy Leung

Table Of Contents

Special Thanks to

God,
For agape love, compassion, amazing grace, wisdom, and strength. And for Jesus, the good shepherd, whose blood covers us all.

Christine and James Zhai
This project wouldn't be possible without your love and support.

Amber Zhai
The Yang to my Ying.

Diana Chen, Lisa Fuller, and Ellen Pilon
For staying on the phone with me and making the phone calls.

Cristina Marzullo, Mel Novak and Judah Smith
For the light compass.

Brant Cooper
Who validates my passion for this project, lean.

Christine Lu
For playing a big game and inspiring me to do the same.

The Love Story Early Supporters, through Thick and Thin
Jess Alter, Wade Chao, Jeredon O' Conner, Derrick Cleveland, Martin Dunkerton, Monica Dziak, Jim Francesco, Benny Flores, Melissa Wynne-Jones, Stephanie Mercado, Sandy Leung, Jennie Nguyen, Leila Pari, Jesse Rivas, Roxanne Ruby, Carlos Sanchez, Yaroslav Sabitov, Dani Silva, Russell Ward, Sherman Wellons, Samuel Zaribian, Amber Zhai

Dedication

This journal is dedicated to the five souls who chose to leave this realm too soon.

Alejandra, a beautiful voice.

Franklin, a beautiful mind.

Susie, a beautiful heart.

Brian and Joshua, two beautiful souls.

Break Your Heart Open
Discover Your Narrative

"For now we see only a reflection as in a mirror; then we shall see face to face. Now I know in part; then I shall know fully, even as I am fully known."

1 Corinthians 13, Bible

The Love Story Journal is designed to validate your pain of loss and to inspire you to transform that pain into creative expression. This half of the journal is designed for you to cry, get angry, and get acquainted with the full spectrum of who you are.

We sometimes get so caught up trying to function in front of family, friends, work, and social settings that we forget to reflect. While keeping up with the status quo to meet expectations and survive the world, we often neglect making time to just be with ourselves, exploring the subconscious that runs our inner dialogue, and deal with what really matters to us. Doing the inner work is necessary to our spiritual and emotional sustenance.

This journal features 40 artists who have not only done the inner work, but who are also willing to share candidly about their experiences going inward. By interacting with this journal, you will also have the space to do your inner work as well.

Having 40 artists share their experiences serves another purpose. When we share from a space of authenticity, we offer ourselves as mirrors to another person's growth. The intention behind the 40 narratives presented in the first half of this journal is so you may begin getting honest with yourself. There is power in connecting with a different person, especially someone from another walk of life.

"Darkness cannot drive out darkness; only light can do that.
Hate cannot drive out hate; only love can do that."

Martin Luther King, Jr.

The journey of self-discovery begins when you shed light upon that which is hidden. The shadow side of you does not want to be called out, because it knows that once you shed light upon it, you have the power to change your actions and create a new narrative. Part of creating a new narrative is discovering and having compassion for the full spectrum of who you are. It begins with identifying yourself in others and getting honest with yourself.

This is your Love Story.

How to Watch the Interviews Inside The Love Story Journal

Step 1:

Download Live Portrait App from your IOS or Android phone.

Live Portrait

Step 2:

Open the App until it shows a scanner.

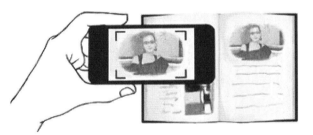

Step 3:

Hover your phone over any one of the artist portraits *(there are 80 throughout this book!)*

Keep hand steady. Make sure your phone is within frame of the picture. Hold for a few seconds over the photo.

Step 4:

The pictures will come alive through your phone.

Step 5:

To "capture" the interview with your phone, double-tap on the phone while the artist is speaking.

Step 6:

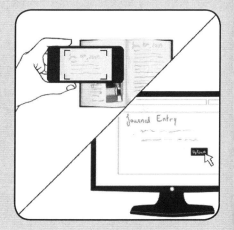

If you like to start journaling from the journaling prompts at the end of each interview, hit pause at the last 5 seconds of the video of your phone.

How to Share Your Journal Entry

Step 1:

Login to:
www.thelovestory.org/weletgo/share

Step 2:

Take a picture of one of the journal entries inside this book. Upload the Journal entry on our website.

Step 3:

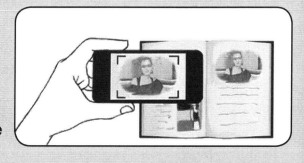

Pick which artist inspired your journal entry.

See your journal entry next to the artist share within a few days!

Break Your Heart Open

"...honestly, I don't ever want to feel that again, but most times that 'never wanting to feel it again' is what makes you push it away."

–Antonique

3

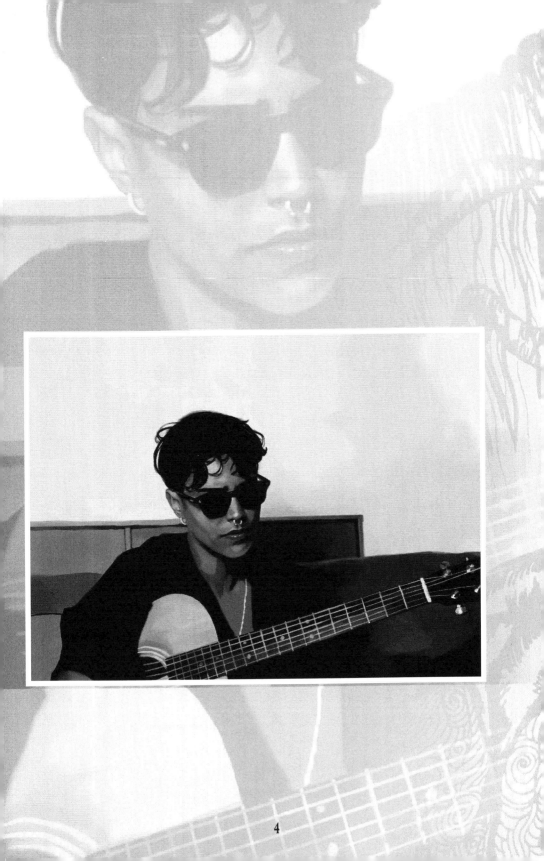

"...it was about losing him as a friend, cause I was an idiot...."
–Kera.

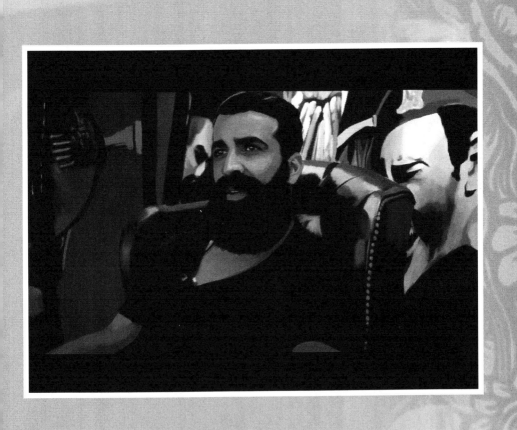

"I think it's amazing
to see a soldier crying
because you see the
humanity in him."
–Tomer

"I did this out of a heartbreak or being sad for not being an artist."
—Lucas

"... HAVE TO
REGAIN MY SELF-
IDENTITY AGAIN
AND COMPOSURE...
MAINTAIN A SENSE
OF SELF-LOVE,
RATHER THAN
NEEDING IT."

—KIYOSHI

19

"I wanted just whatever he would give me... ."
—Krista

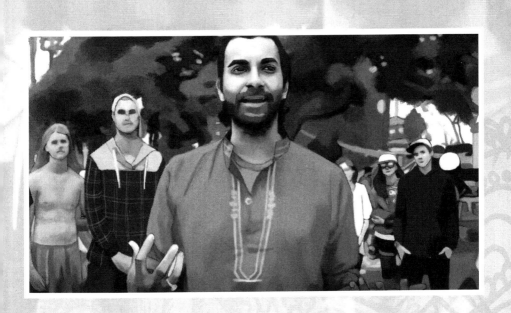

"It's like clothing. Sometimes, pain stains your clothing in such a way that you can wash it as much as you want, and it takes several washes to get it out... ."
—Indy

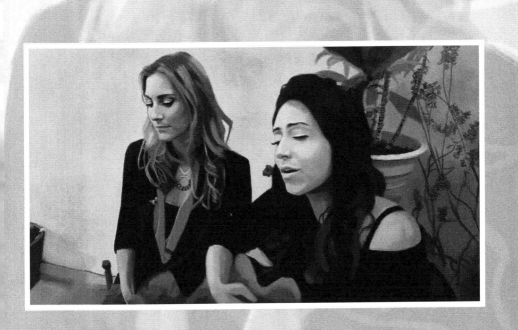

"It allowed me to feel what unconditional love feels like, where there might not be anything in it for you, but this person is experiencing a great life accomplishment and life path... ."

—Jamee

"Those moments when...he's off...it's like, 'Okay, I can let go and have the ability to love you no matter what, no matter where you are.'"

—Larisa

"I WAS ALMOST WHAT YOU WOULD CALL, ON 'SURVIVAL MODE'..."
-MICHELLE

34

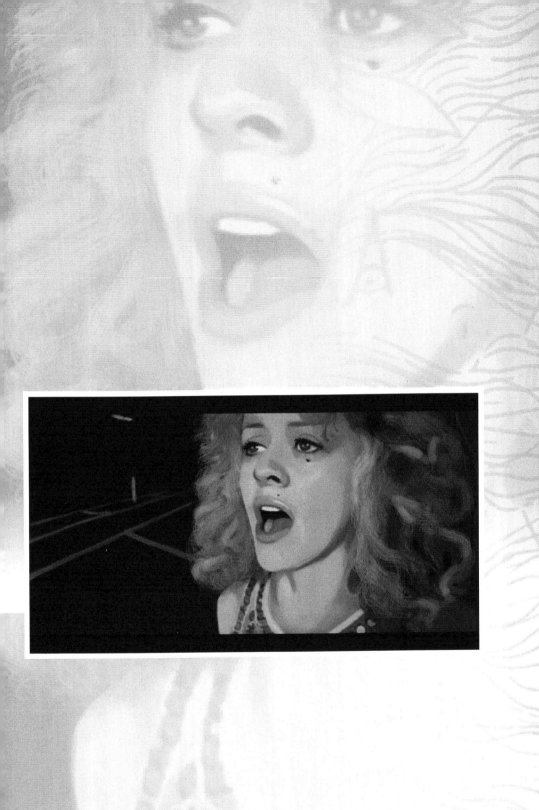

"You're angry at
yourself, you're
feeling guilty, you're
obviously angry at the
perpetrator, you're
angry at the people
who let it happen."
—Andrea

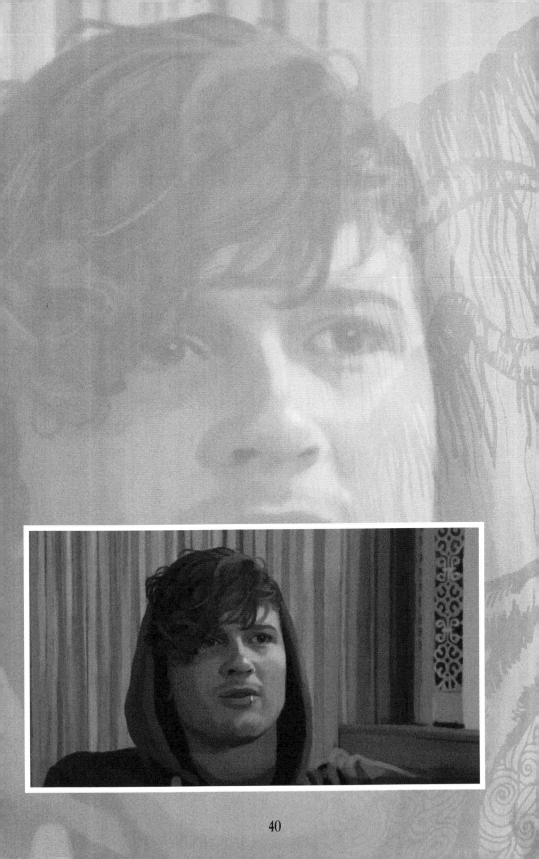

"When you feel sadness and you see it as something that's negative, then you fight against it, and it leads you into this hopeless spiral of depression. But when you see it as something that's uniquely beautiful, just as beautiful as joy...the sad parts of life are just as beautiful as the happy parts of life, if not more, in my opinion."

—Justin

"I was edgy and angry because I basically knew that he was going to die, and I didn't want to accept it."
—Mick

"She doesn't want me to calm her down, which is another way of saying, 'look, get smaller, shrink, shrink what you're doing. Stop expressing so much because I can't handle that.'"
–Bryan

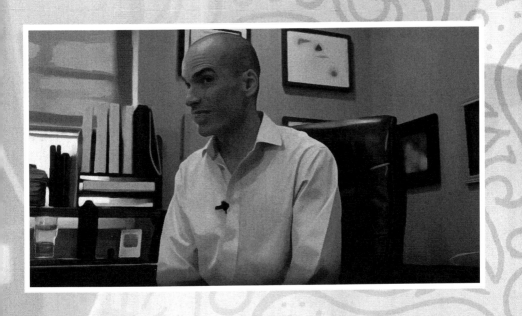

"Oh no you didn't. No, you didn't just—pardon my french—You didn't just F—with me. That's just mean...."
—Tim

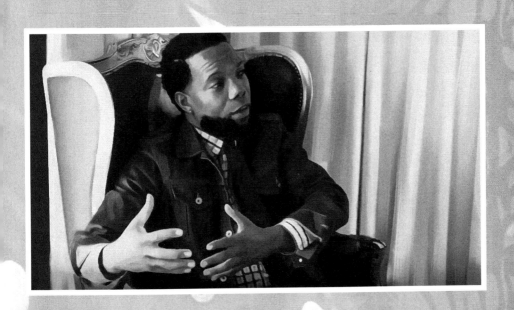

"THE CHALLENGE IS ONCE YOU EXPERIENCE THOSE EMOTIONS, HOW DO WE TRANSCEND OURSELVES FROM THAT TO GROW BEYOND THAT HATE AND ANGER AND BITTERNESS AND INNER TURMOIL?"
-KWEISI

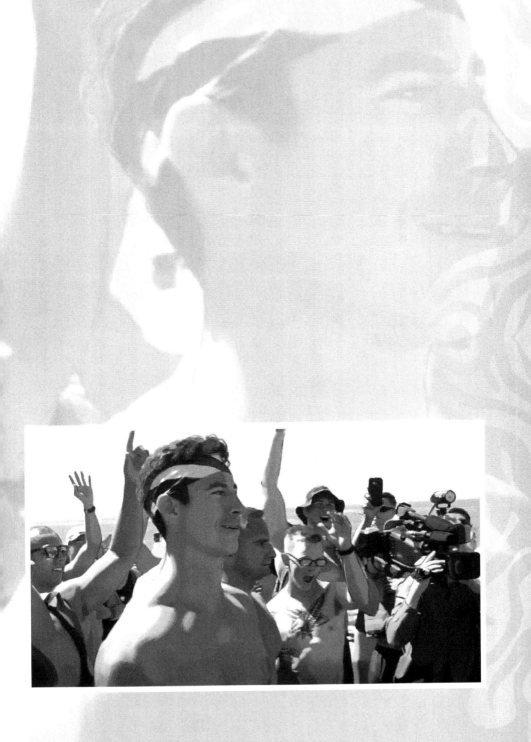

61

"My need to give meaning to his death that caused me to dedicate the book to suicide, and use the book as a platform for preventing it."
—Donny

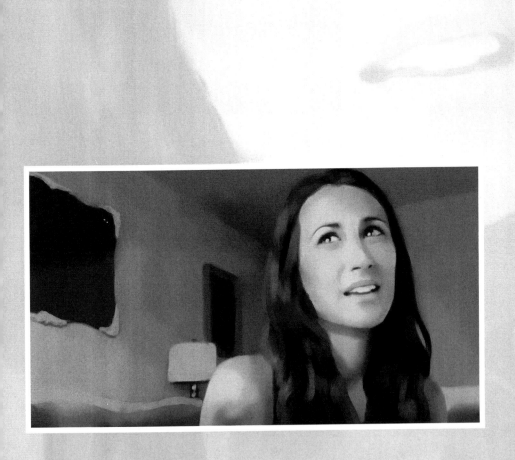

"...these emotionally abusive things, and just this addiction to it, and when I find somebody that is sweet and loving... would treat me right, I would just be like, 'eh'... ."
—Julia

"It started to build up, and it got to a really dark place."
—Matt

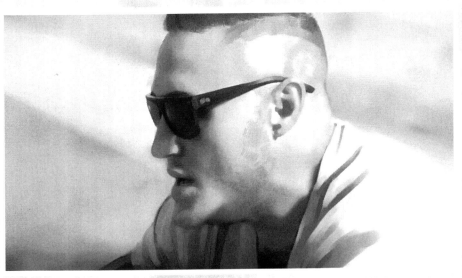

"CERTAIN SITUATIONS AND CERTAIN FEELINGS AND EMOTIONS, I WOULD CALL IT AS A SEPARATION ANXIETY. SEPARATING FROM WHAT YOU KNEW AND WHAT MADE YOU EFFECTIVE INTO WHO YOU ARE RIGHT NOW."
—MIKE

"When you fall in love with someone so deep in the hole... it hurts you also...."
—Hennessy

"Everything that people tell you...
'Don't be with someone who is
abusive, don't be with someone who
talks badly or treats you badly'...yet in
it, you feel like you can change that
person or you feel like you can fix it.
Part of you feels like you deserve it...
like they're right."
–Josephina

"THEN, THIS DOCTOR SAID TO ME, 'LOOK KID, YOU THINK YOU'RE EVER GOING TO PLAY BALL OR DO ANYTHING AGAIN, FORGET IT, YOU'RE GOING TO BE A CRIPPLE FOR THE REST OF YOUR LIFE.' THAT WAS BRUTAL."

–MEL

"YOUR FAN BASE IS THE
ENERGY THAT YOU PUT OUT
THERE, SO IF YOU PUT OUT
THERE NEGATIVITY, IF YOU
PUT OUT THERE WORRY,
DOUBT AND FEAR, THE
PEOPLE WHO SUPPORT
THOSE TYPES OF SOUNDS,
THEY'RE GOING TO SUPPORT
YOU IN CONCERT."

DJ QWESS COAST

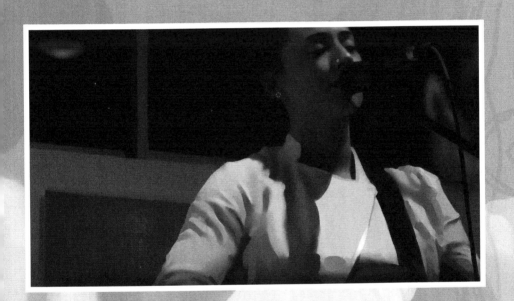

"SOME OF THE MOST
DEEP SUFFERING
AND QUESTIONS OF
'WHY AM I HERE?
WHAT IS THIS ALL
ABOUT? WHAT'S THE
POINT? WHAT AM
I REALLY DOING?
WHAT IS THIS PLACE
THAT I LIVE IN?'…."
—LARISA

"Marriage/divorce, job/fired, love relationship/no relationship, is for your highest good."

—Cheri Rae

" 'Why did you have to die?' I think that's a question I have been asking myself so many years, you know?"

—Danny

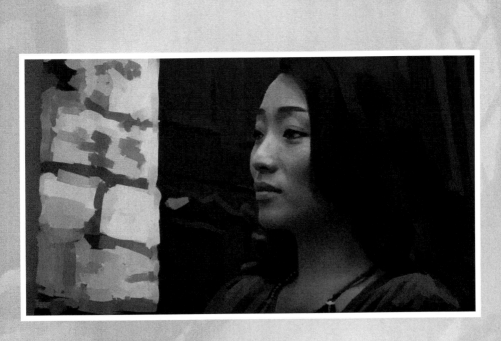

"They don't know why I'm here. I will show them why I'm here. That's like the first stage of transmuting anger."

—Jessica

"It was very very difficult
when you're young, and
you have to hide from your
identity, and you're carrying
so much pain..."

–Jelveh

113

"In some way,
everything I do is
inspired by love
and loss."

—Dream

115

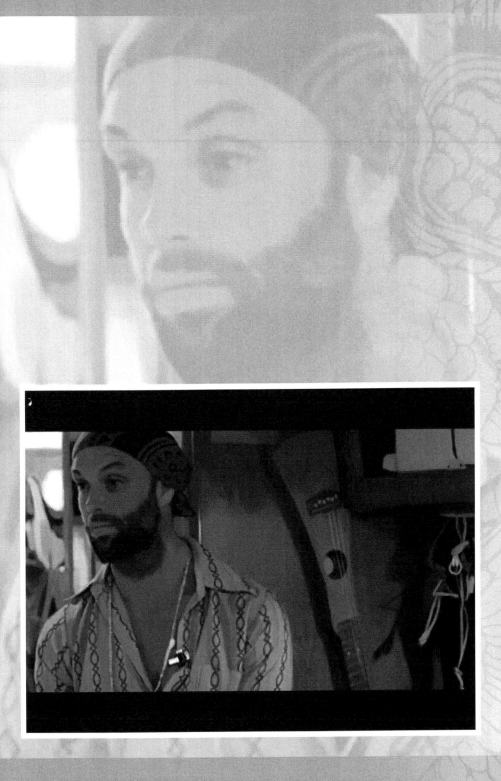

You don't have to get personal about that. It's just that person's process and, you know, ultimately it's better to love them from allowing them to follow their path alone until they find that sense of balance and you find that sense of balance within you."

—Samuel J.

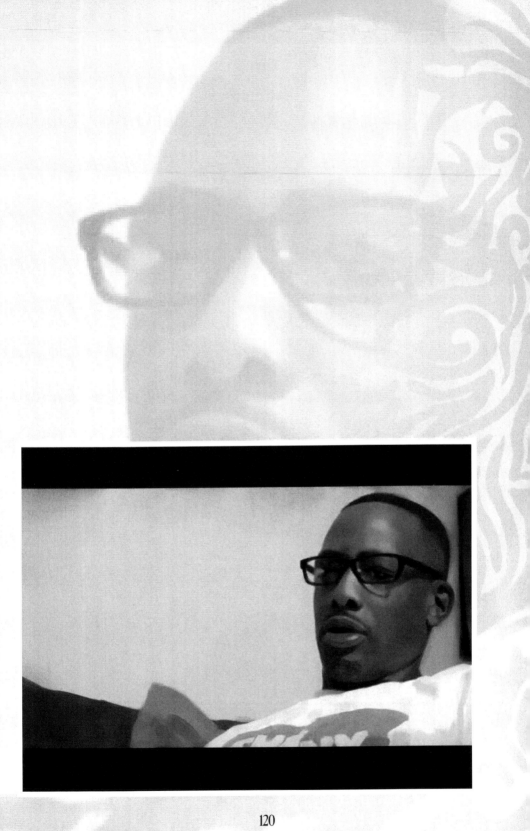

"THAT STUFF
STARTED HITTING ME,
AND IT DROVE ME TO
CREATE THE RECORD
WITH MY BAND."
—KEITH

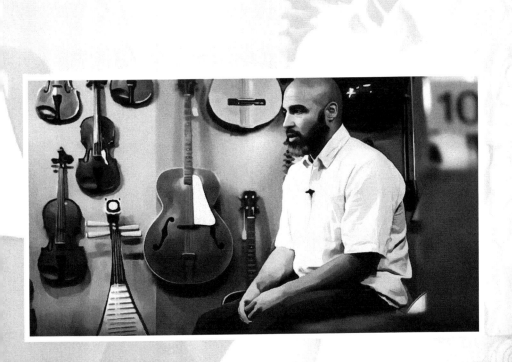

"I CAN TAKE THAT
EXPERIENCE AND FEEL
LIKE I WAS CHEATED OF A
FATHER...I CAN TAKE THAT
PATH...OR I CAN SAY, 'HERE'S
A GUY WHO LIVED HIS LIFE
AND HAD A PROFOUND
IMPACT ON THE PEOPLE HE
INTERACTED WITH."

—PETER

"Understanding
that even within
darkness, there is
so much choice."
—Moby

"I get a stomach ache. My body is unable to do things. It's just hard."
–Marisabel

"That's what she says in her song. She's completely crazy. This woman, but that's what a woman thinks when she feels that the man she loves is going away."

–Cecile

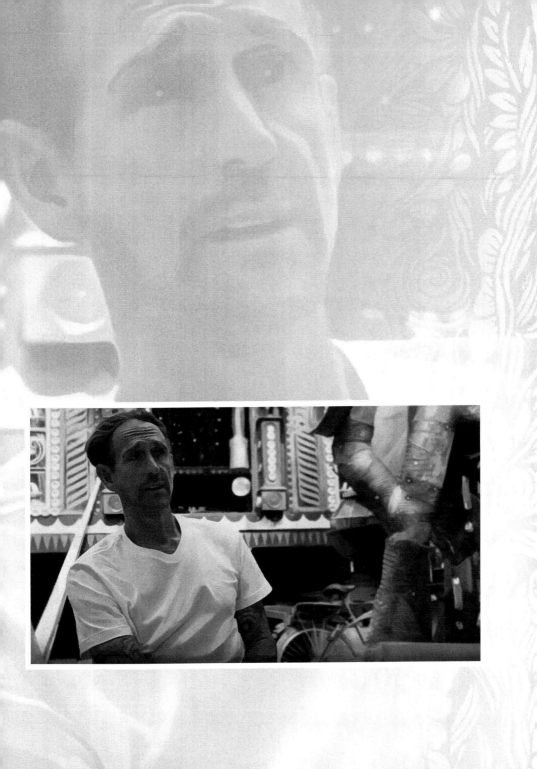

"AT A PRETTY YOUNG AGE, MY SELF-ESTEEM WAS BEGINNING TO BE COMPLETELY CRUSHED, AND WHEN YOUR SELF-ESTEEM IS CRUSHED, IT'S VERY HARD TO GO THROUGH THE WORLD OR TO WANT TO LIVE."

-SHRINE

"That state of shock
lasted for a long time,
even though I knew this
was happening."

—Sara

"AT SOME POINT I THINK THAT'S JUST THE HUMAN EXPERIENCE. YOU REBEL. I THINK I ENLIGHTENED MY FATHER, AS TO SOME OF THE OPINIONS HE HAD, AND I THINK I LEARNED FROM HIM, THAT SOME OF THEM WASN'T THE BEST IDEAS, BUT THAT'S PART OF MY DUALITY."

–RAS

153

"It had to be broken
for her in order for
her to move on. I was
kind of devastated,
but kind of resigned."

—Martin

"It was rough. I was sitting up all night writing poetry, I couldn't sleep...you know, really pushing myself...not taking care of myself."

–Rohan

159

"Unlike gold, the more you share love, you don't have less of it. There is no finite amount."

—Rohan

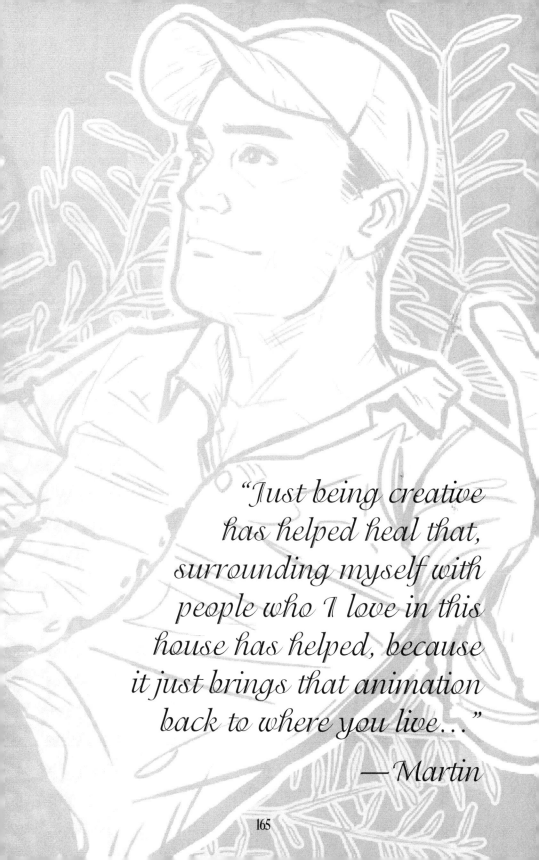

"Just being creative
has helped heal that,
surrounding myself with
people who I love in this
house has helped, because
it just brings that animation
back to where you live…"

— Martin

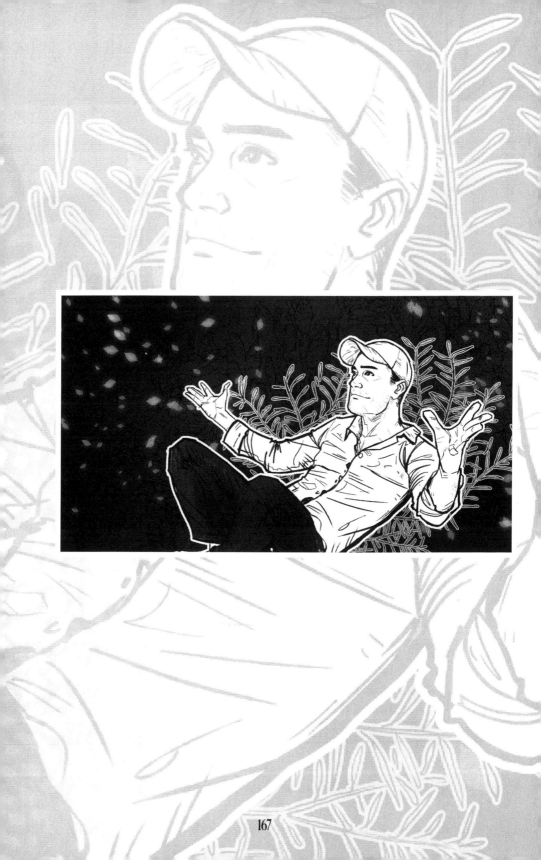

"Started learning about history. Questioning the things society teaches us probably when I was in the seventh grade, and that led me into reading about and later on taking classes about cultural anthropology, physical anthropology, history, prehistory, linguistics... ."

—Ras

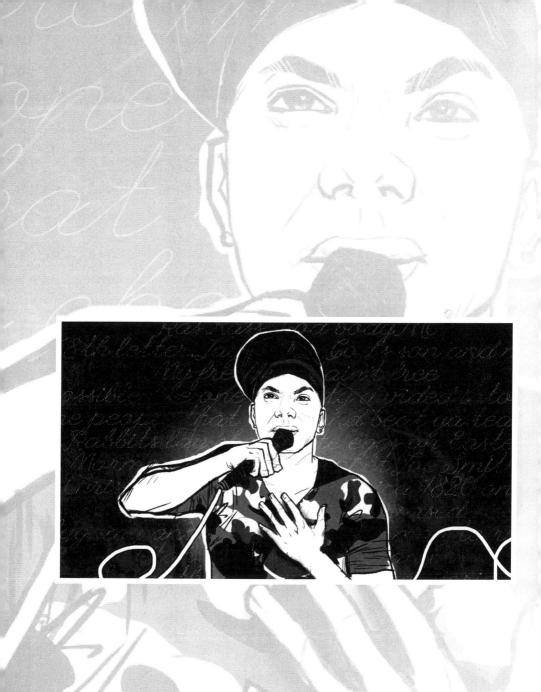

"I FEEL LIKE, ALMOST
EVERYTHING THAT
HAS HAPPENED TO
ME, HAS SORT OF
BEEN A TRAINING FOR
BEING ABLE TO HOLD
PEOPLE'S PAIN THIS
PARTICULAR WAY."
—SARAH

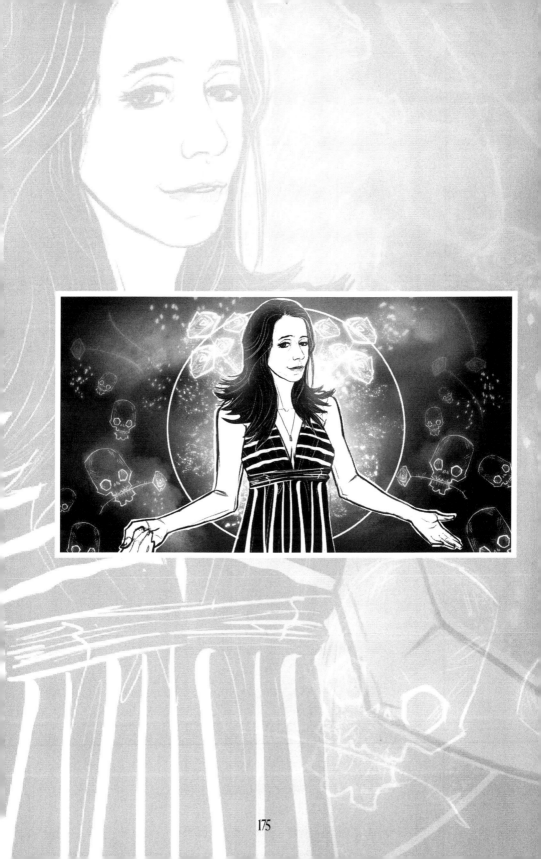

"Life is constantly and continually changing, faster than you can even keep track of it really."

—Shrine

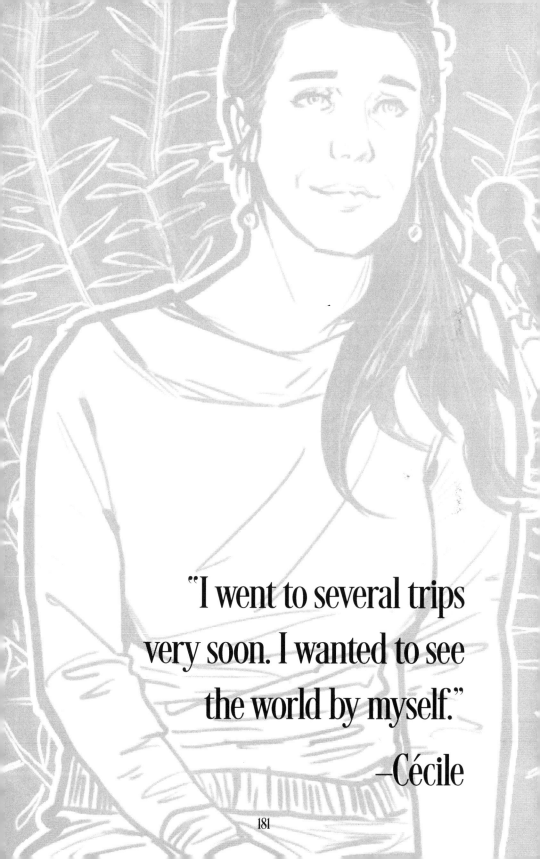

"I went to several trips
very soon. I wanted to see
the world by myself."

–Cécile

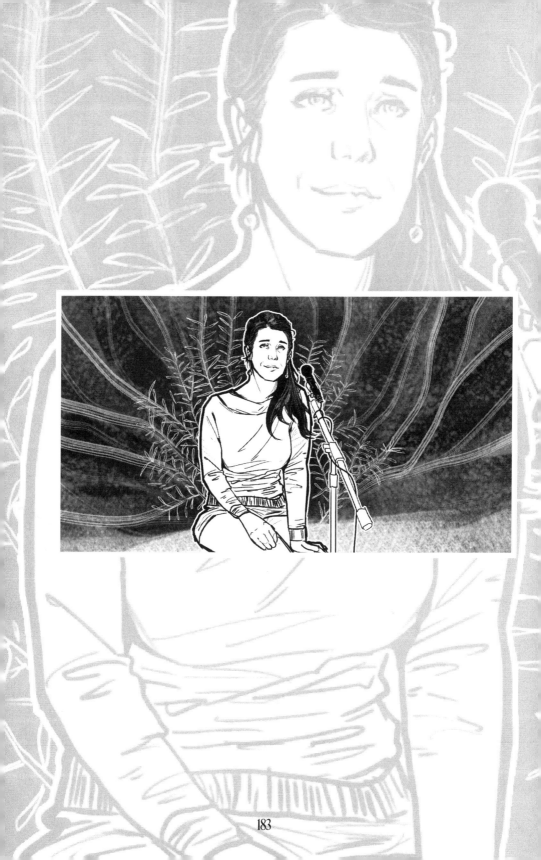

"I always look for support. My friends. My family lives far away so my friends are my family. I have amazing friends."

—Marisabel

"EVERYTHING ENDS.
THERE'S NOT A SINGLE
THING THAT YOU CAN THINK
OF OR EXPERIENCE OR
HAVE...THAT DOESN'T END."
—MOBY

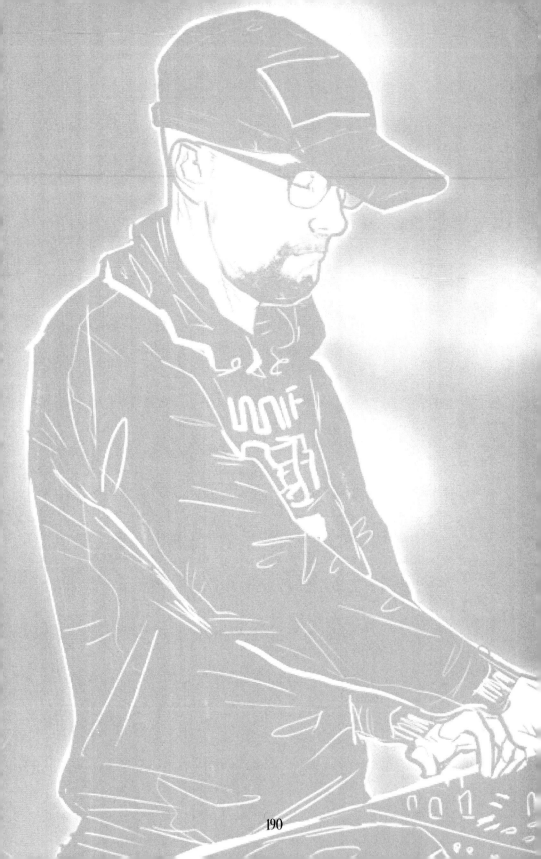

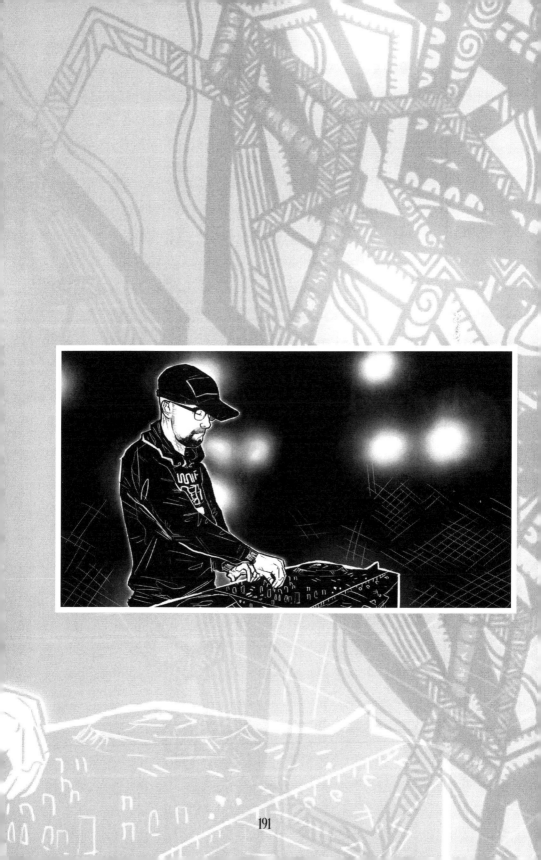

"Even though it's antithetical, vulnerability is truly in and of itself the only real power that an individual has. All of your strengths are actually all of your weaknesses."

—Peter

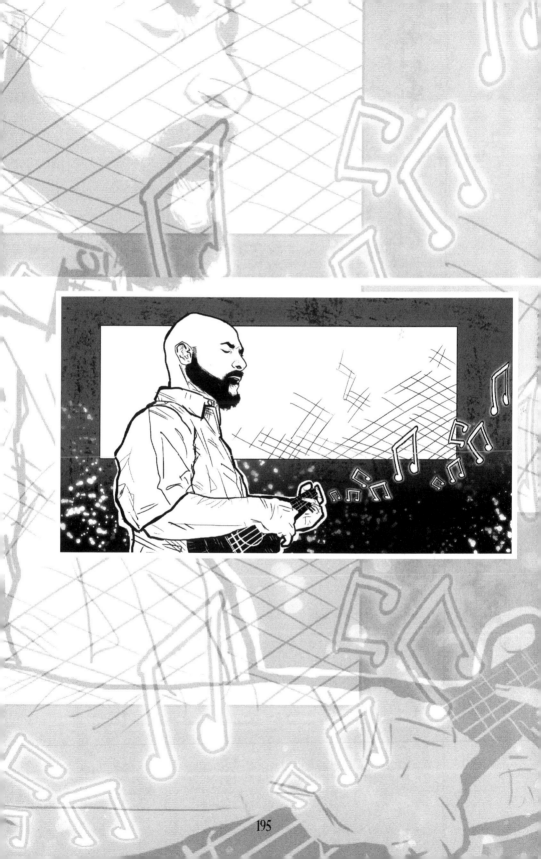

"A SENSE OF PURPOSE...
YOU GET A GOOD SWEAT,
YOU WIN YOU LOSE,
YOU GO BACK TO THE
DRAWING BOARD, YOU
TRY HARDER, YOU GET
YOUR ACCOLADES, ALL
AMERICAN, ALL LEAGUE,
GOING TO THE DINNERS,
GOING 52 POINTS."

–KEITH

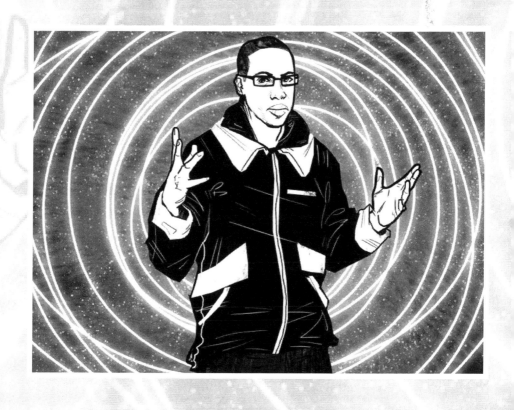

"MY PARENTS
ALWAYS TOLD ME
THAT WORRYING IS
A TEMPTATION BUT
NOT A SOLUTION
FOR ANYTHING."

—SAMUEL

"Even when you're breaking out, you still don't know that you're a butterfly. You actually don't know that you're a butterfly until you are all the way out."

—Dream

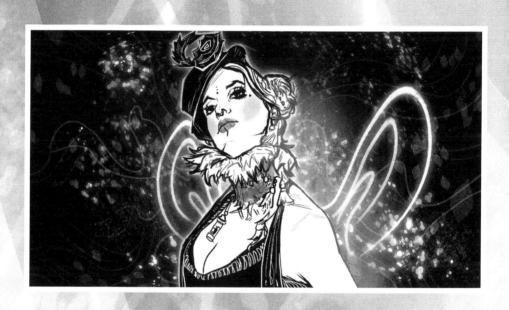

"When you're surrounded by your loved ones, your parents and now you're a mom, there was tremendous healing that came from that. *This* became my home."

—Jelveh

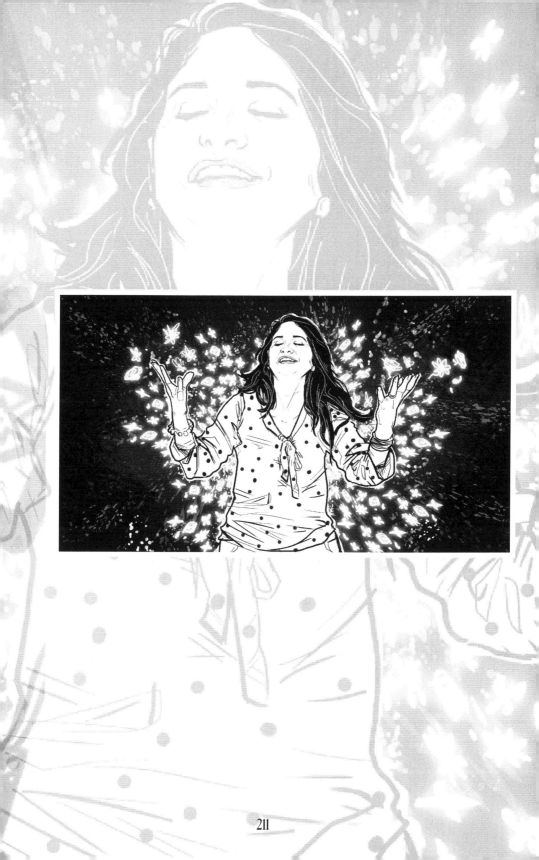

"Instead of asking them, why are they behaving this way, I ask myself, 'Did I behave with integrity? Did I behave with love? Did I show them my love?' "

—Jessica

THE

CAR

AND THE

216

"I'm the same person
I was when I was
younger, it's just I got
hit with these problems
so the song is really
about breaking down
those barriers and
those divisions... ."

—Lauren

THE
CAR
AND THE
218

THE BODY IS THE CAR

AND THE SOUL
IS THE DRIVER

"The more we give,
the more we receive,
so give it away,
give it away, give it
away now."
—Cheri Rae

222

"When we lose love, it's always worth it, because of the experiences we gain from love."
—Larisa

228

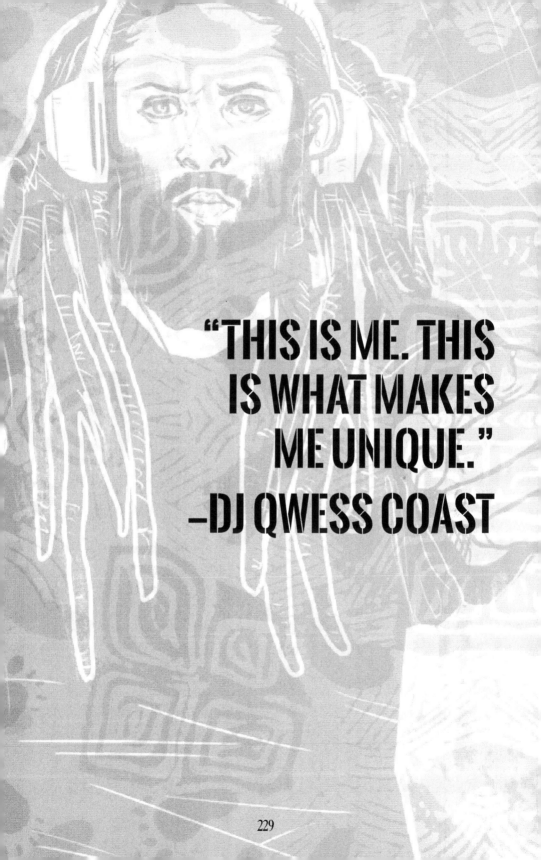

"THIS IS ME. THIS IS WHAT MAKES ME UNIQUE."
–DJ QWESS COAST

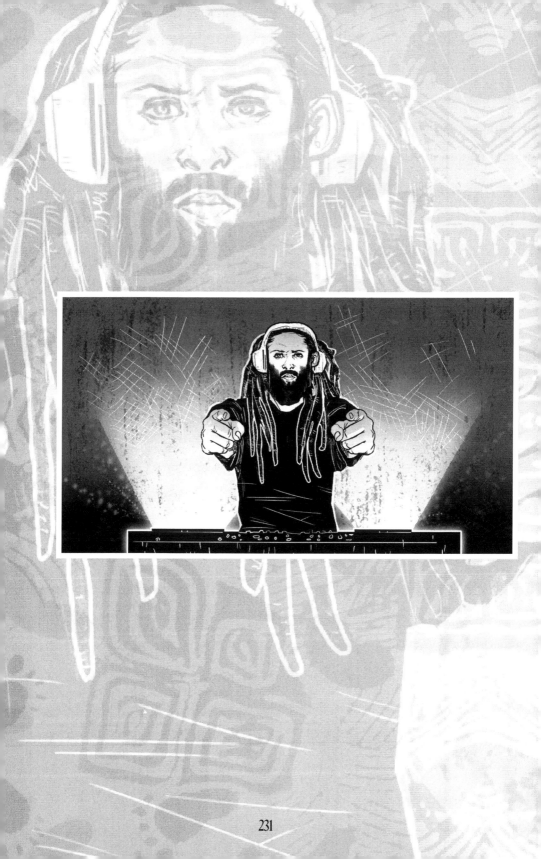

"You just reach out and help. From the skid row, it transitioned right into the prison ministry."

—Mel

"I prayed. I just went back to my prayer and continued to ask everyday for the strength of the angels and the strength of God."

—Josephina

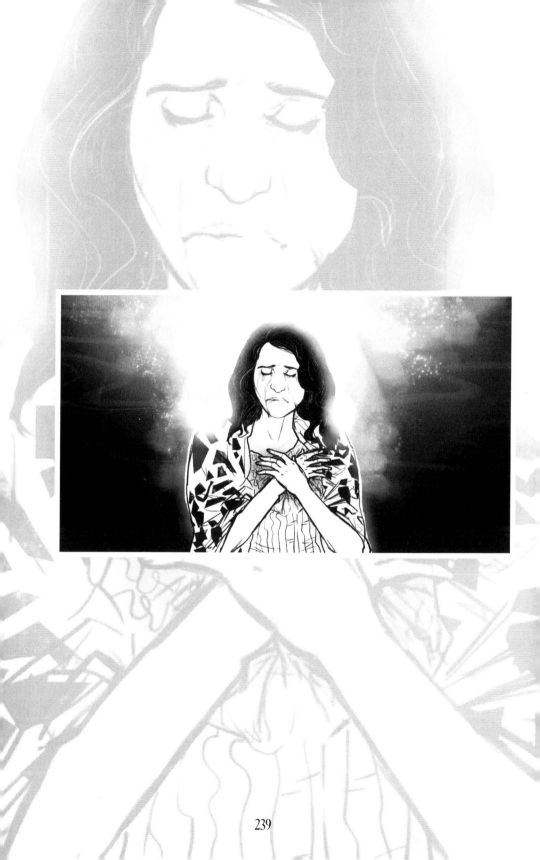

"People are going through their own stuff and they take it out on others, and you have to understand that it's not you."

— Hennessy

242

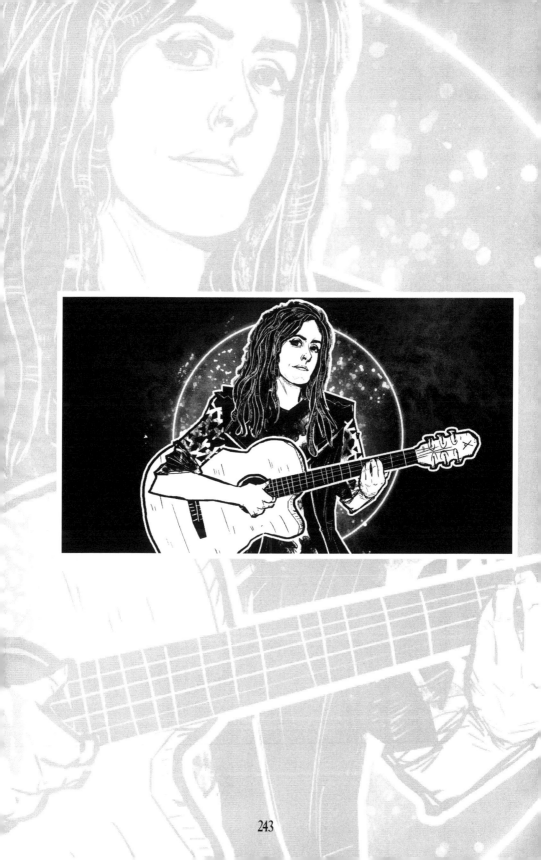

244

"...and for them to come back here and die stateside...die in the United States when they served and did all these deployments elsewhere, it's what hits ya."

—Brent Olds

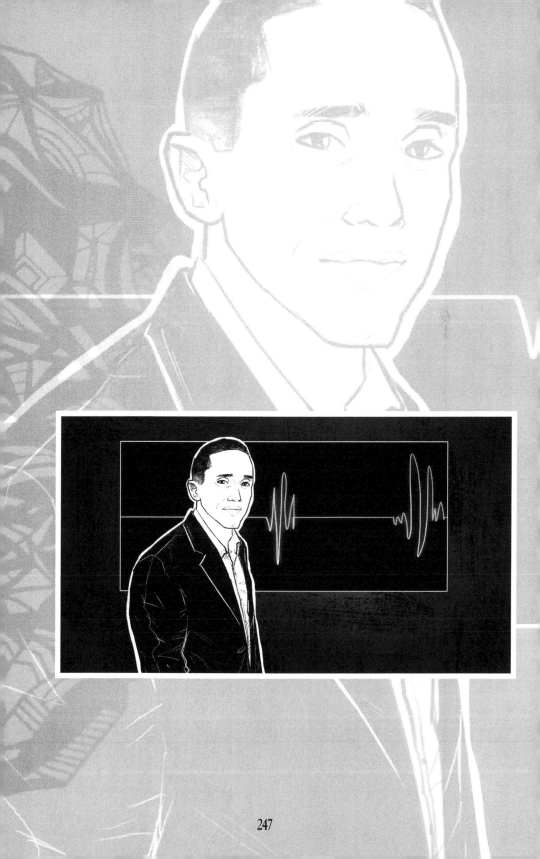

"I might as well provide this for something where people can see it rather than just keeping it to myself."

–Matt

"Going through those breakups can actually and completely open up your heart and show vulnerability that I have never experienced."

—Julia

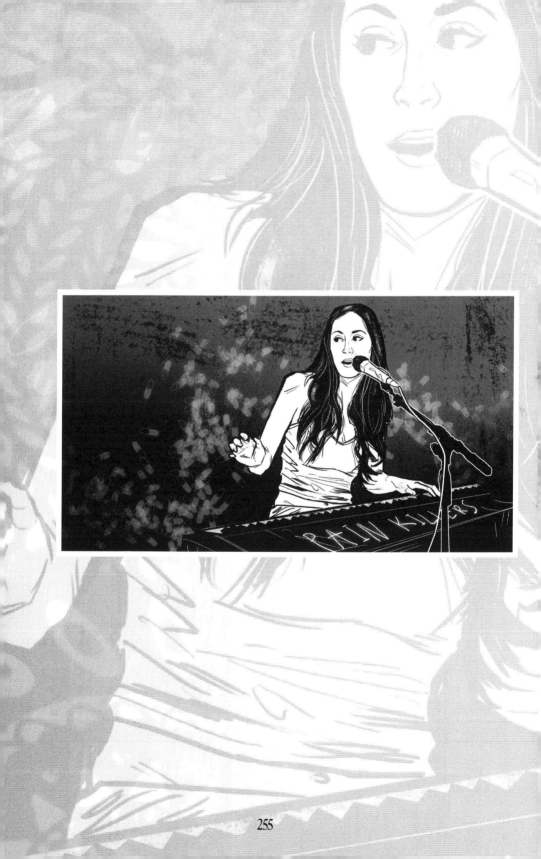

"It was the love I have for the guys I served with that motivated me to create something that can bring them together."

—Donny

"That's where my anger and rage went into...was my art...and that was how I was able to let it out."

—Kweisi

"YOU'RE ALREADY SAD. THE REASON YOU ARE DRAWN TO THE MUSIC IS BECAUSE THAT IS VALIDATING HOW YOU FEEL... ."

—TIM

266

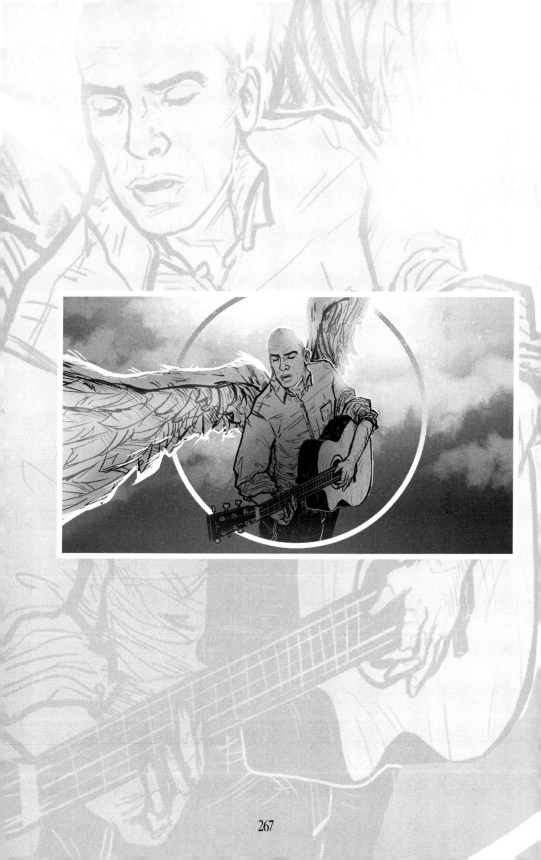

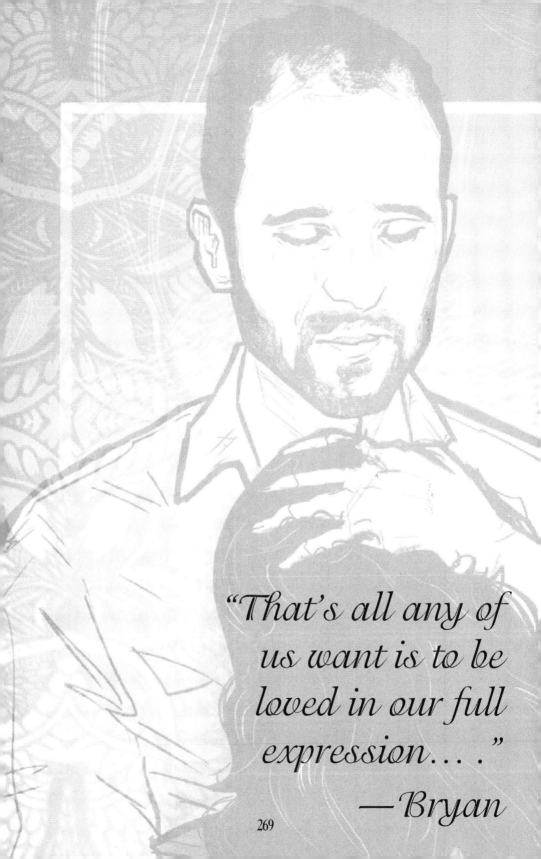

"That's all any of us want is to be loved in our full expression…."
—Bryan

269

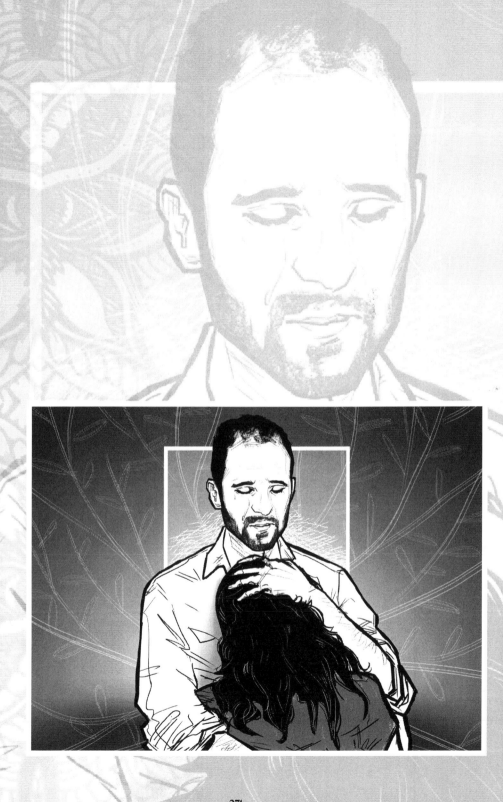

"A LOT OF THE
FIRST WORK THAT
I MADE AFTER MY
FATHER PASSED WAS
ACTUALLY QUITE
MESSY AND ANGRY
AND TORMENTED."
–MICK

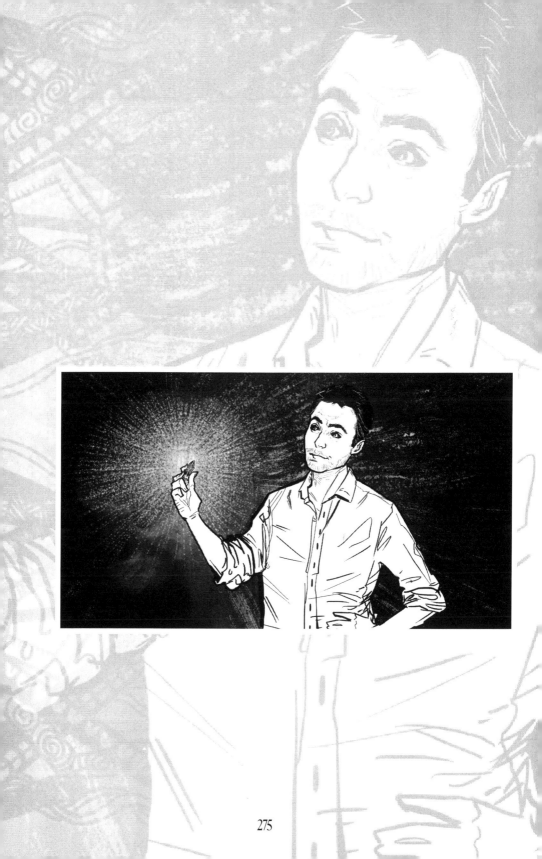

"...when in reality the entire time, I should be just making what I liked."

—Justin

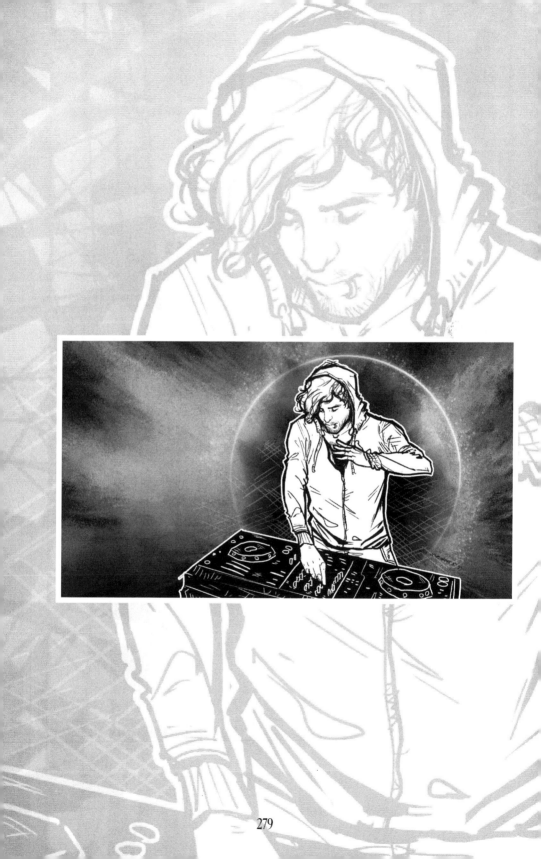

"'What you did on that stage, what you showed, is what I lived.'"
—Andrea

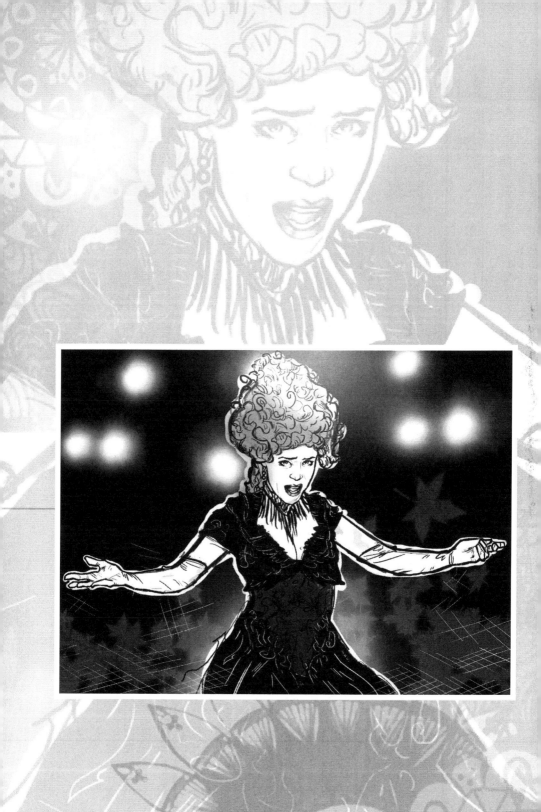

"It was sort of prompted by the idea of bringing strangers together around a table."

—Michelle

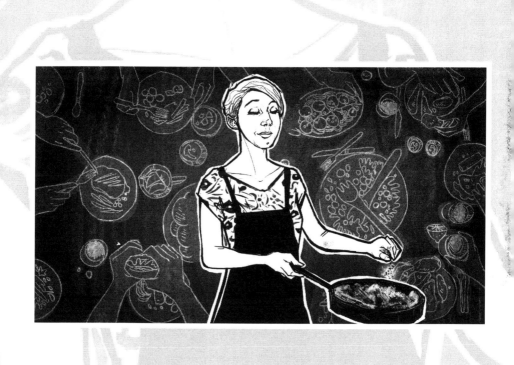

"All of that
expansiveness of
feeling so deeply,
which is a gift that we
get to feel deeply."
—Jamee

"My perspective on pain is that it is
neither good nor bad, it simply is an
emotion, and it's always showing us,
always teaching us."
—Larisa

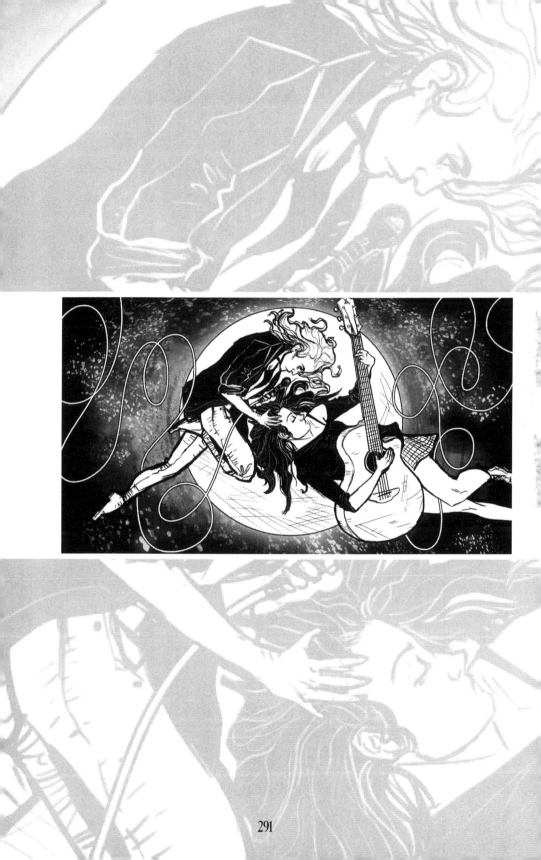

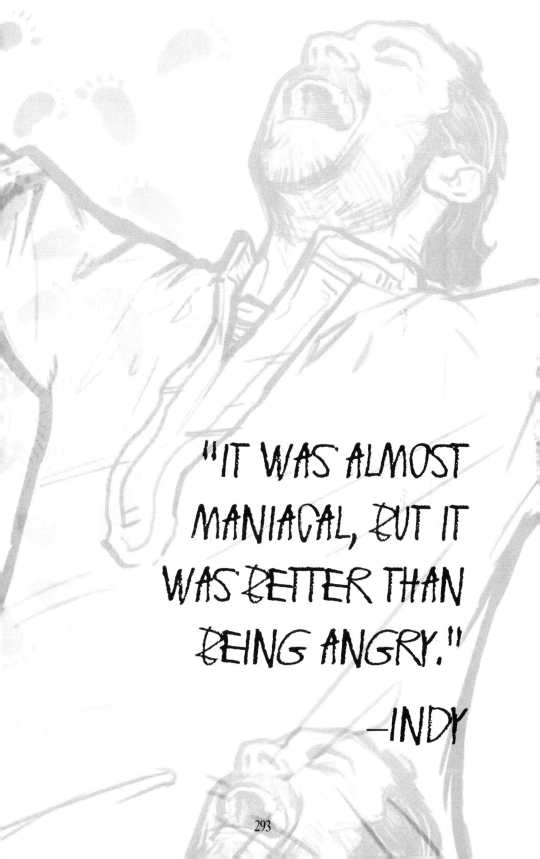

"IT WAS ALMOST MANIACAL, BUT IT WAS BETTER THAN BEING ANGRY."

—INDY

"Just the process of writing down,
even just lyrics, or whole song,
actually for me is so healing..."

–Krista

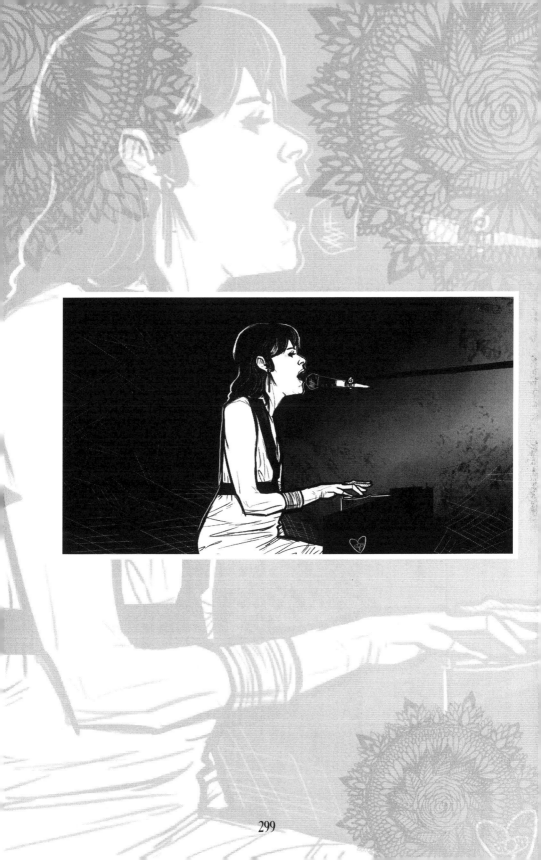

"Exploring the emotions that I was going through at the time, accepting it, and letting it run through."
— Kiyoshi

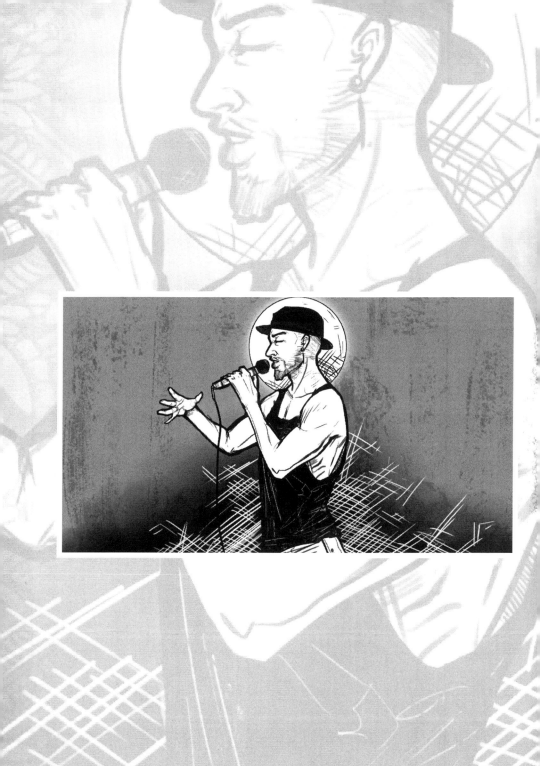

"I DIDN'T MAKE NORMAL THINGS. I THINK THAT'S THE REASON WHY I LEARNED DRAWING, BECAUSE I WAS JUST HOME, JUST PRACTICING."

—LUCAS

"Creating art and using that art as a medicine on you, this is the best medicine ever."

—Tomer

"You have to deal with it at some point. Numbing it does nothing. It's always going to be there."

–Kera

314

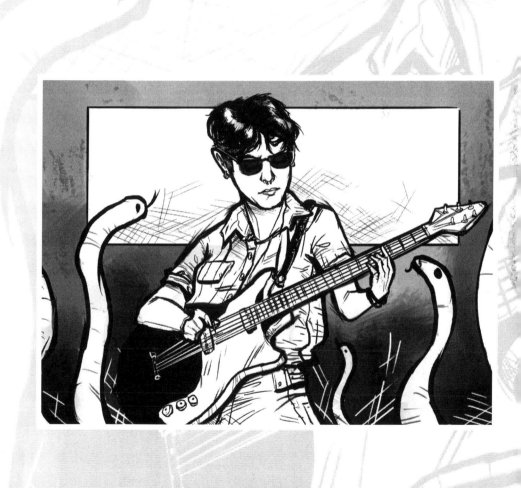

"INITIALLY, YOU JUST
FEEL IT. YOU'RE EATING A
BUNCH OF ICE CREAM AND
WATCHING *SEX AND THE
CITY* AND CRYING..."
—ANTONIQUE

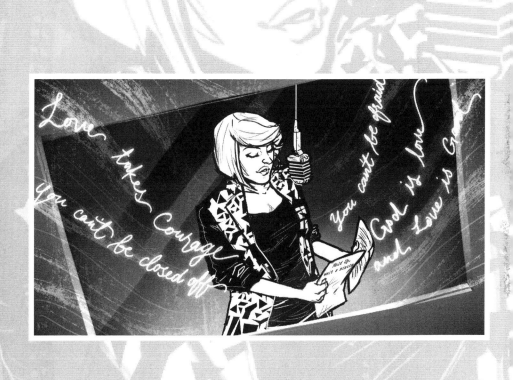

THE ART OF LETTING GO

How to Watch the Interviews Inside The Love Story Journal

Step 1:

Download Live Portrait App from your IOS or Android phone.

Live Portrait

Step 2:

Open the App until it shows a scanner.

Step 3:

Hover your phone over any one of the artist portraits *(there are 80 throughout this book!)*

Keep hand steady. Make sure your phone is within frame of the picture. Hold for a few seconds over the photo.

Step 4:

The pictures will come alive through your phone.

Step 5:

To "capture" the
interview with your phone, double-tap
on the phone while the artist is speaking.

Step 6:

If you like to start journaling from
the journaling prompts at the end of
each interview, hit pause at the last 5
seconds of the video of your phone.

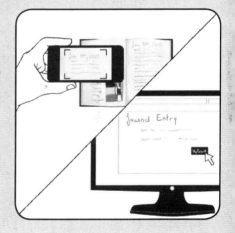

How to Share Your Journal Entry

Step 1:

Login to:
www.thelovestory.org/weletgo/share

Step 2:

Take a picture of one of the journal
entries inside this book. Upload
the Journal entry on our website.

Step 3:

Pick which artist inspired
your journal entry.

**See your journal entry
next to the artist share
within a few days!**

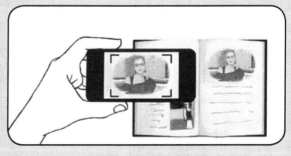

The Art of Letting Go
Transform your Pain into Passion

"A miracle is a shift in perception from fear to love."

Marianne Williamson

Even as you are reading this, it may seem impossible, so far off, so hopeless to shift the gear from fear to love. It may be so overwhelming at times that we don't even know where or how to begin processing our emotions. This half of the journal exists to provide inspiration and encouragement for our process.

Because we also have all walked through hell, and someway, somehow, walked far enough past the fire to tell our tale, we are gathered in this journal to share our process so you may do the same with yours. It comes with one caveat—it doesn't mean we have "solved the mystery," defeated sorrow, or that we won't hurt again. We are all human, and this is is still a human experience.

"For a seed to achieve its greatest expression, it must come completely undone. The shell cracks, its insides come out and everything changes. To someone who doesn't understand growth, it would look like complete destruction."

Cynthia Occelli

Often the act of creating is the act of letting go. Letting go of what, you may ask? Letting go of the emotions that do not serve your higher purpose--anger, resentment, bitterness, hopelessness, despair, self-loathing, etc. The key ingredient is in the letting.

It is when we begin honoring our process that we begin recognizing our inner artistry for what it is. You will experience the highs and

lows of the journey. You will make mistakes, feel impatient, feel stuck. You will do it anyway and create your first drafts, perhaps ruminate and torture over them until your stomach turns. You will question it, hide it, reveal it, then change it, add to it, experience a high and then a low from it. The process repeats. You will experience all the emotions—shame, guilt, fear, passion, love, conviction—in the pursuit of art. Finding the courage to continue pushing forward so you may push through—this is how we let go through art.

By transforming those emotions into a creative endeavor—an art piece, a poem, spoken word, music lyrics, song, a book, a project, a character and so on—rather than making the emotions wrong by suppressing it, you are showing compassion and providing a funnel through which they can be expressed. Sometimes, the deeper our wounds, the more depth and insight we have about other people, about ourselves, and about life. This part of the journal is where you can begin to leverage your pain into the artistic form.

"Lonely and Alone: There's a difference."

Jerhia

We want to let you know that you may be lost right now, but you are not alone. And though you have to walk it alone, take comfort in knowing that all of us have had to walk it alone at some point or another. If you were gifted this journal, that is one way of reminding yourself that someone out there is expressing love for you. And if you happen to have gifted this journal to yourself, you are making the conscious choice to express self-love. If that is the case, more power to you. Because true love is generated from within, The Love Story Journal is designed to be a solo experience, guided by different voices and personalities of both this journal and in this life. For this half of the journal, you will be prompted at the end of each interview to interact with the outer world and in turn, rediscover your inner world.

This is where your self-discovery and growth continues.

Dedication

This journal is dedicated to the five souls who chose to leave this realm too soon.

Alejandra, a beautiful voice.

Franklin, a beautiful mind.

Susie, a beautiful heart.

Brian and Joshua, two beautiful souls.

Credits:

Executive Producer:
Mingjie Zhai

Associate Producers:
Wade Chao
Monica Dziak
Sandy Leung
Leila Pari
Sherman Wellons

Video Editor: Mingjie Zhai
Sound Editor: Seth Brogdon
Editor-in-Chief: Mingjie Zhai
Assistant Copy Editors: Alex Jacobs, Stephanie Mercado, and Mingjie Zhai

Cover Illustration and Mandala: Jesse Alter
The Love Story (Front Half) Portrait Illustrator: Sirine Cherif
The Art of Letting Go (Back Half) Portrait Illustrator: Xiao Ming Tang
Graphic Designer: Justin Oefelein

In Partnership with: Live Portrait

Table Of Contents

The Love Story:
The Art Of Letting Go